OUR LOVE OF
Owls

Stan Tekiela

Adventure Publications
Cambridge, Minnesota

Dedication

To Rich T., Matt M., Joe G. A lifetime of friendship.

Edited by Sandy Livoti
Cover and book design by Lora Westberg
Front cover: Snowy Owl
Back cover: Northern Hawk Owl
All photos by Stan Tekiela

10 9 8 7 6 5 4 3 2 1

Our Love of Owls
Copyright © 2018 by Stan Tekiela
Published by Adventure Publications
An imprint of AdventureKEEN
330 Garfield Street South
Cambridge, Minnesota 55008
(800) 678-7006
www.adventurepublications.net
All rights reserved
Printed in China
ISBN 978-1-59193-813-2 (pbk.)

Symbol of Wisdom, Mystery and the Night

Of all the birds in the world, I think it is the owls that capture the interest of so many—and I am no exception! I've always had a special place in my naturalist heart for owls. The reason behind this magnetism may be that owls are unlike other birds. For instance, they have large heads that are as wide as their shoulders. Their eyes are in front of their heads, and their eyelids close from the top down, like ours, making them look somewhat like people. From a distance, their low hooting can even sound human. Most owls are nocturnal and hunt under the cover of darkness. Add to this that owls are top predators, and you have a winning combination of smart looks, power and skill.

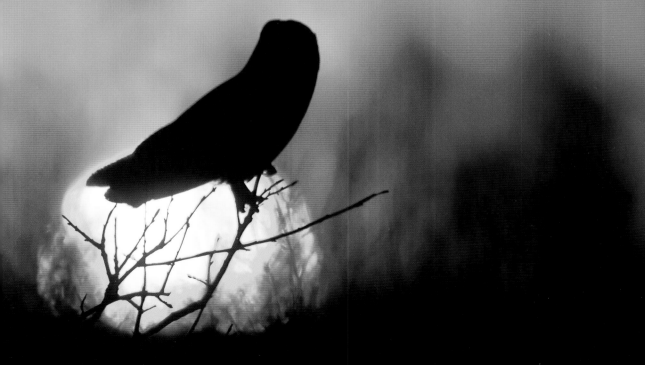

Birds You Can't Mistake

Owls are very unique! Most birds have well-defined, broad shoulders, small heads, small eyes on the sides of their heads, and large bills, but owls are different. They have distinctive barrel-shaped bodies and huge, round heads with large eyes in front, and small, almost hidden, bills. Some owls also have feather tufts on top of their heads that look like ears. With an extra vertebra in their necks, owls are able to turn their heads around much farther than other birds.

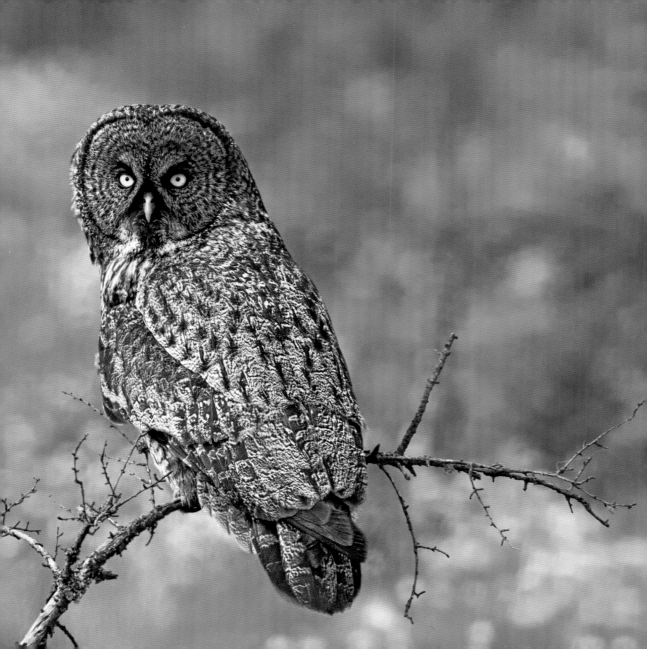

Are They Really Smart?

Owls have large heads for their large eyes and brains, but are they really smarter than other birds? Well, owls do have several social behaviors that are consistent with intelligence. Barn Owls gather in communal shelters for safety, while Short-eared Owls hunt in flocks to find food. Some owl species communicate through a variety of social signals, including touching, vocalizing and posturing. Owls also preen each other while making soft, reassuring sounds, both of which are also signs of elevated intelligence.

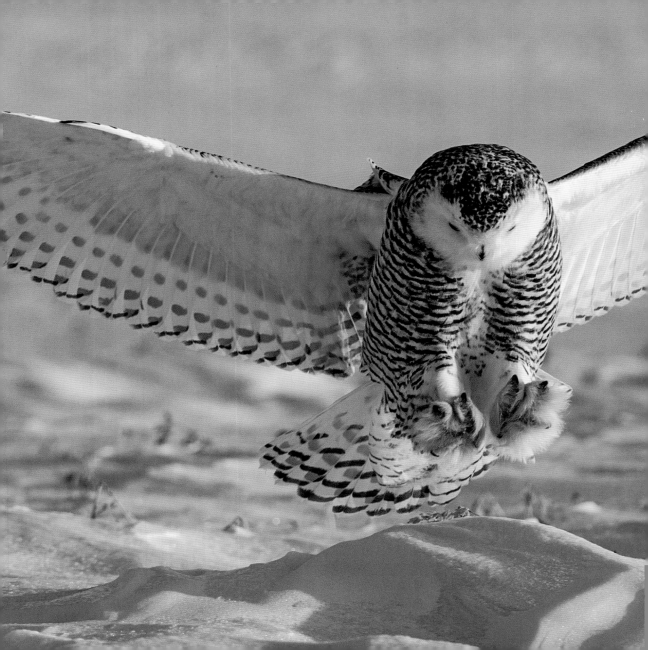

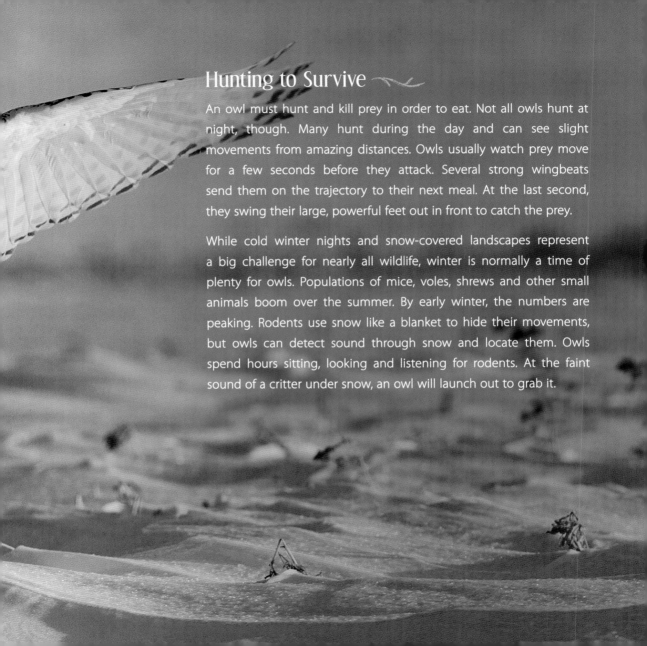

Hunting to Survive

An owl must hunt and kill prey in order to eat. Not all owls hunt at night, though. Many hunt during the day and can see slight movements from amazing distances. Owls usually watch prey move for a few seconds before they attack. Several strong wingbeats send them on the trajectory to their next meal. At the last second, they swing their large, powerful feet out in front to catch the prey.

While cold winter nights and snow-covered landscapes represent a big challenge for nearly all wildlife, winter is normally a time of plenty for owls. Populations of mice, voles, shrews and other small animals boom over the summer. By early winter, the numbers are peaking. Rodents use snow like a blanket to hide their movements, but owls can detect sound through snow and locate them. Owls spend hours sitting, looking and listening for rodents. At the faint sound of a critter under snow, an owl will launch out to grab it.

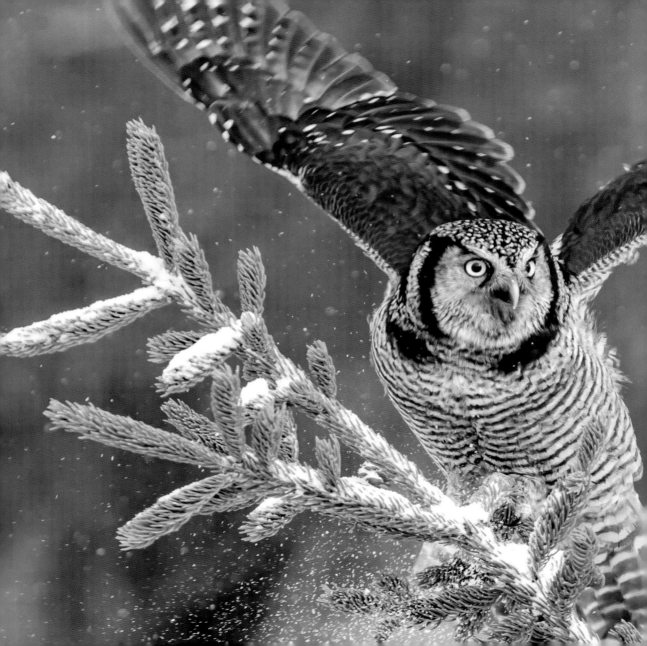

The World through Their Eyes

Owl eyes face forward like ours, but unlike our round eyeballs, theirs are tubular. Compared to their heads, their eyes are huge. In some species, the weight of their eyes is more than that of their brain! Their eyes are actually too large to move within the sockets. Instead, owls are able to swivel their heads to about 270 degrees left or right, thanks to the extra vertebra in their necks. This gives them a much greater range of sight than we have, even when we move our eyes and turn our heads at the same time.

Many owls can see two to three times better than people, but the way they see and perceive the world is very different. Northern Hawk Owls and many other daytime-hunting owls are fast fliers. It has been shown that they acquire focus, called accommodation, at about 100 times per second. This is more than 10 times faster than we can focus. No wonder owls can zip through a forest but not run into small branches!

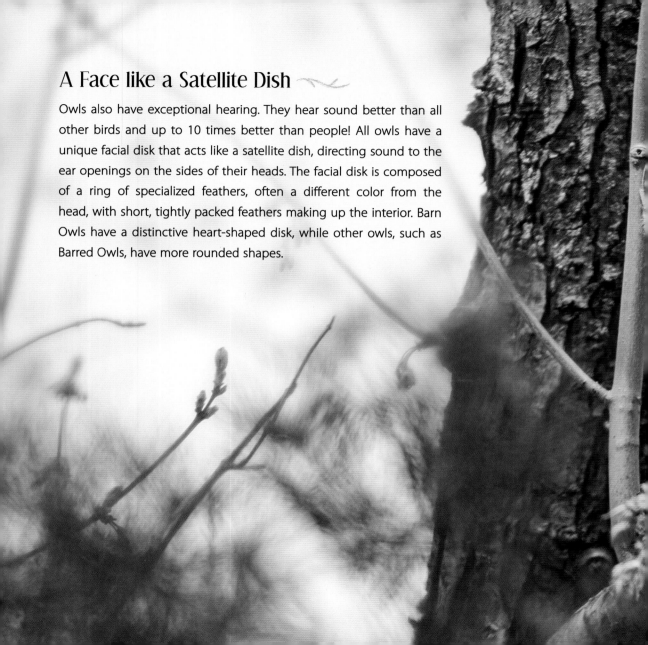

A Face like a Satellite Dish

Owls also have exceptional hearing. They hear sound better than all other birds and up to 10 times better than people! All owls have a unique facial disk that acts like a satellite dish, directing sound to the ear openings on the sides of their heads. The facial disk is composed of a ring of specialized feathers, often a different color from the head, with short, tightly packed feathers making up the interior. Barn Owls have a distinctive heart-shaped disk, while other owls, such as Barred Owls, have more rounded shapes.

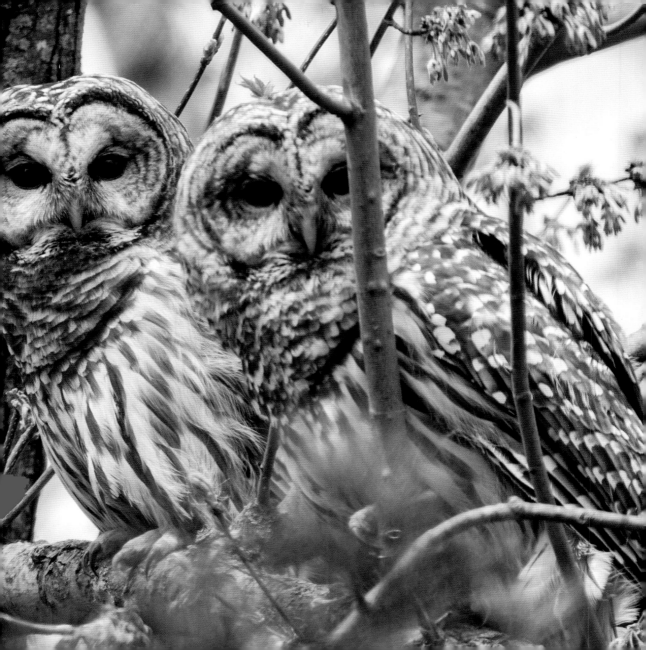

Sensitive Hearing

Many night-hunting owls have asymmetrical ear openings, with one larger opening and one higher opening. This arrangement allows sound to enter the ears at slightly different times and enables owls to triangulate the sound and pinpoint its origin. Daytime hunters have less asymmetry than owls that hunt strictly during the night. Daytime-hunting Snowy Owls have very little asymmetry, while night-hunting Boreal Owls have the greatest. All owl species have movable earflaps, both externally and internally, for muffling their hearing so they can get some sleep!

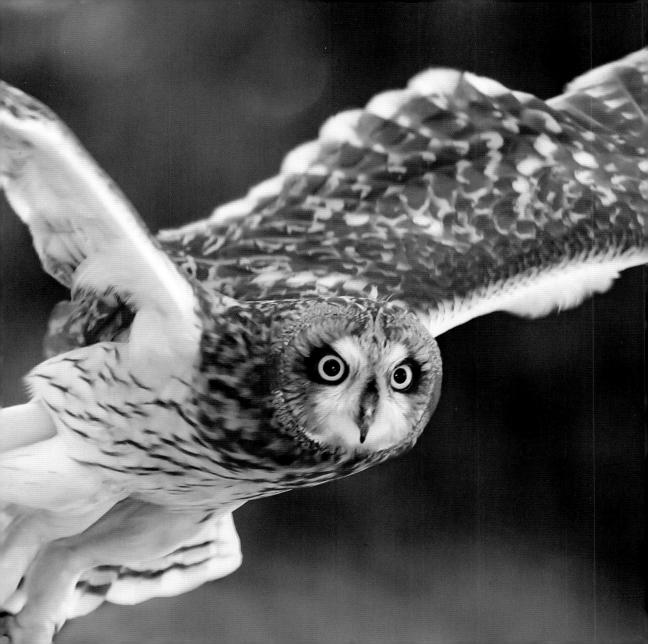

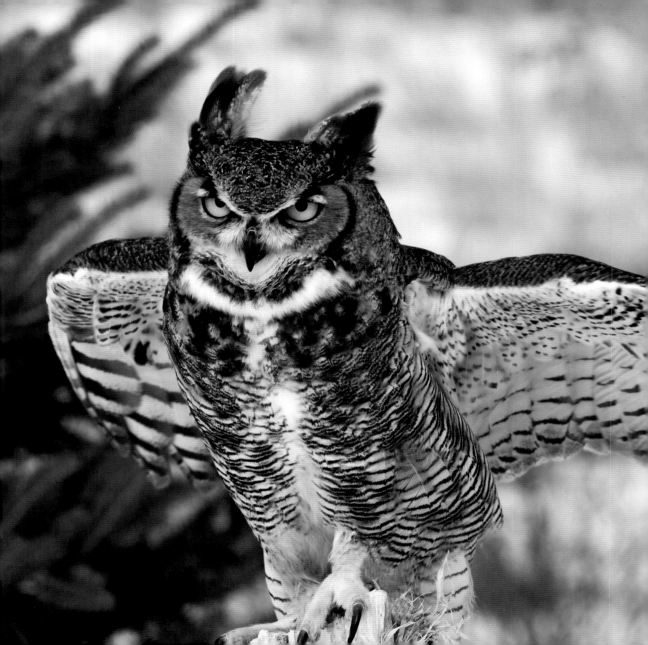

Feather Tufts: Extra Ears or Horns?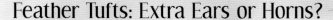

Owl ear tufts, also called horns, are simply tufts of feathers on the head and have nothing to do with hearing or horns. Some owls have extra-long tufts, while others just have tiny collections of feathers. Worldwide, about 40 percent of all owl species have ear tufts. Of the 19 species in the United States and Canada, about a third are "eared" or "horned" owls. We may never know why some species have feather tufts. Because owls raise and lower the tufts according to their temperament, some believe it helps with communication. Others think the tufts help camouflage perching owls and help them blend into the environment during the day.

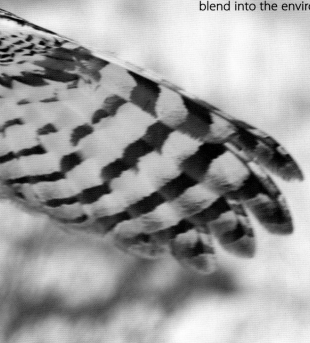

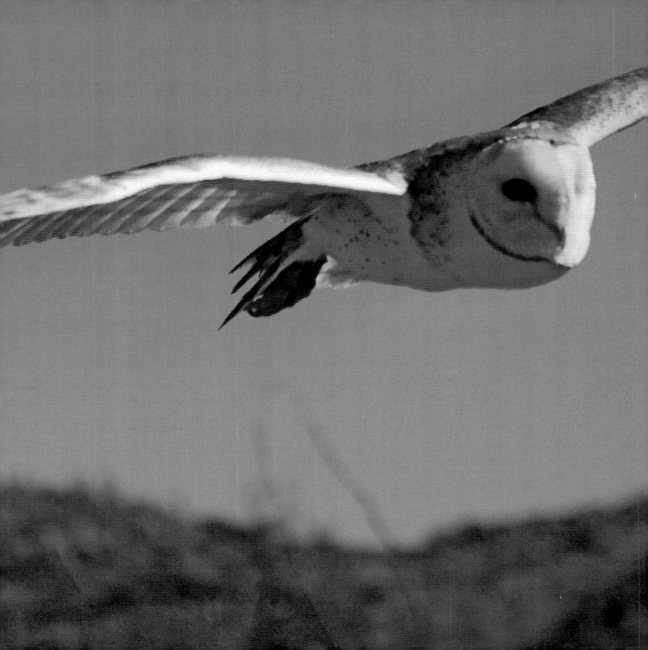

Absolute Silent Flight

Most owls have specialized feathers that enable them to fly silently. Silent flight allows owls to keep listening for movement and lock onto the position of their prey. In an experiment to prove silent flight, 10 sensitive microphones were set up in a line. When an owl flew a few feet over the equipment, no sound could be detected.

Other birds make fluttering sounds in flight. When they fly, turbulence made by the wind moving over their wing feathers creates noise. The modified feathers of owls, however, work to silence turbulence. First, the surface of most of their wing feathers has a velvety cushion that reduces the sound of one feather rubbing over another. Second, their flight feathers have serrated, leading edges that break up turbulence and dampen sound. Third, the trailing edges are ragged. Acting like a silencer, these fragment any further turbulence and eliminate noise.

Those Daunting Feet and Talons!

Owls have large, powerful feet with four toes, each tipped with a long, sharp nail, called a talon. In all owl species, three toes face forward and one faces back. When owls perch on a tree branch, they usually swing one toe backward so that two toes grip the front of the branch and two hold onto the back. Owls use this two-forward, two-back toe arrangement, called zygodactyl, when catching prey.

Many northern owl species, such as Snowy and Northern Hawk Owls, have well-feathered feet and toes for warmth. In southern species, such as Burrowing and Elf Owls, the feet and toes are naked.

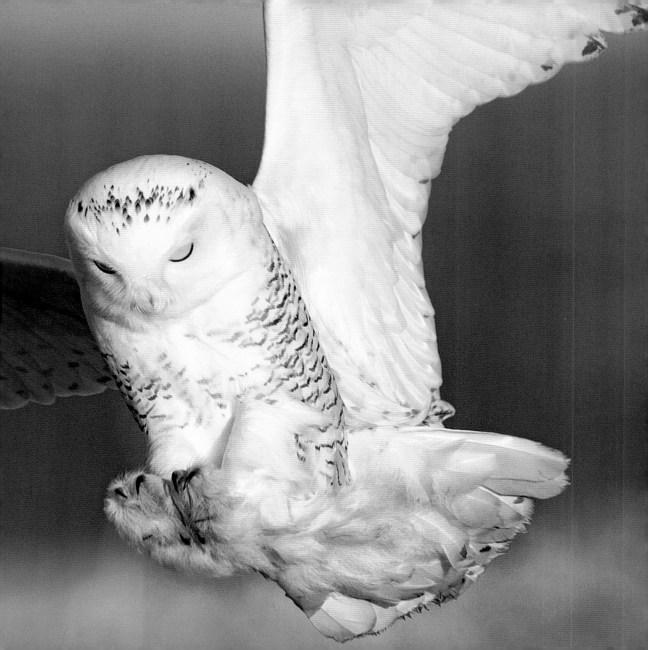

What? The Females Are Larger?

In most bird species, males are larger than the females. In all owl species, however, the females are slightly or noticeably larger than the males. This phenomenon is called reversed sexual dimorphism, but the reason for it is unknown. It is thought that female owls may have adapted to increase in size, as this would have helped them keep the eggs warm. Over time, they also may have become better at defending territory during the mating season and protecting their young while the males hunted. Concurrently, the males may have become smaller and more agile, making them better hunters.

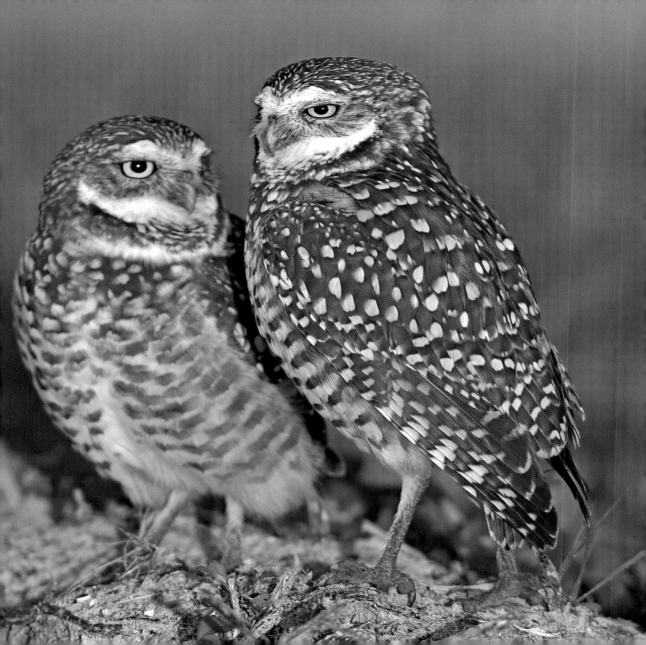

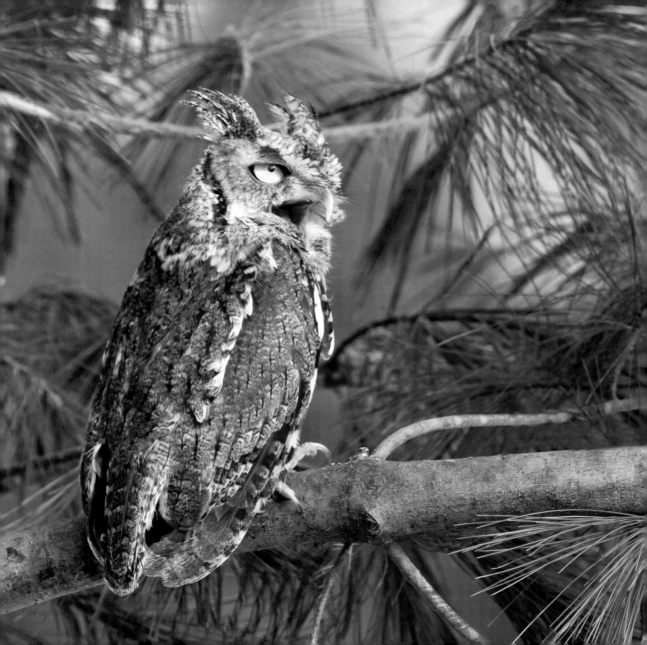

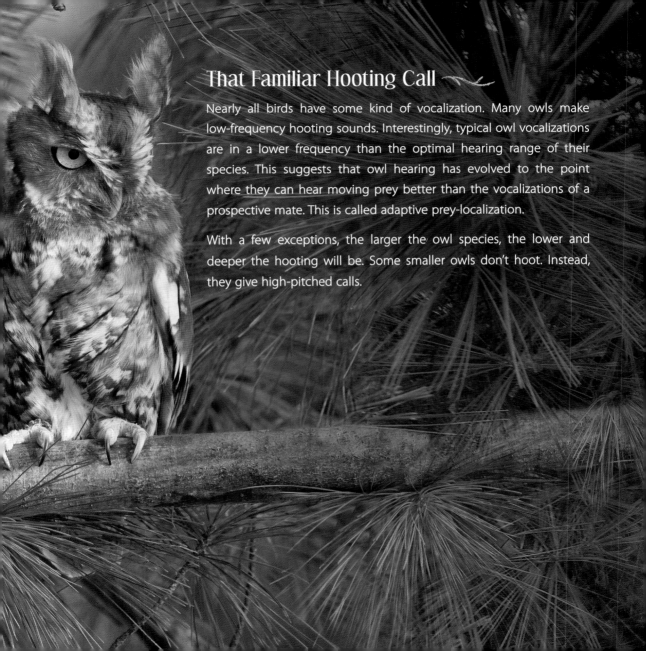

That Familiar Hooting Call

Nearly all birds have some kind of vocalization. Many owls make low-frequency hooting sounds. Interestingly, typical owl vocalizations are in a lower frequency than the optimal hearing range of their species. This suggests that owl hearing has evolved to the point where they can hear moving prey better than the vocalizations of a prospective mate. This is called adaptive prey-localization.

With a few exceptions, the larger the owl species, the lower and deeper the hooting will be. Some smaller owls don't hoot. Instead, they give high-pitched calls.

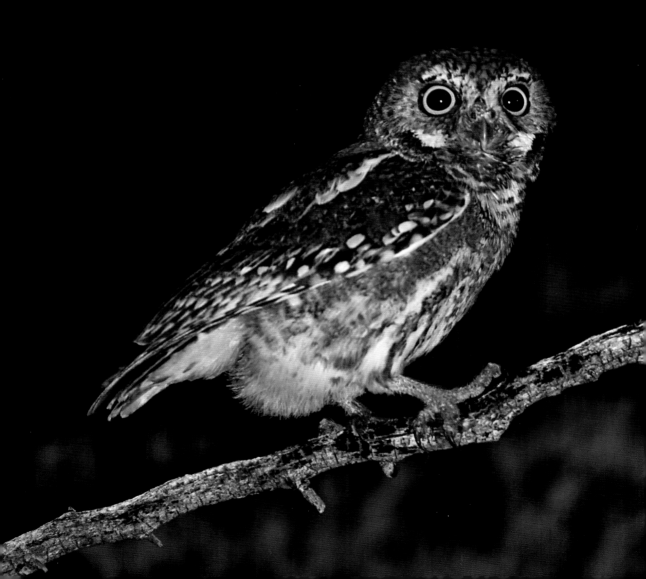

At Home in the Territory

Generally, the largest owls live in colder northern regions, while the smallest species are found in hot, southern areas, such as the U.S. Southwest. Larger owls retain more body heat, which helps them stay warm. Smaller owls shed more body heat, helping them keep cool.

The size of the territory depends on the size of the species. The larger the owl, the larger the territory will be. Territory size can sometimes vary, depending on the food supply. Great Horned Owls patrol smaller territories when prey is abundant. When food is scarce, they need larger territories, upwards of 2 square miles. Smaller owls, such as screech-owls, have territories of about 1 square mile. Most owls are territorial and defend their nests, but they often don't strictly enforce the boundaries. Sometimes the female owl will help the male defend the territory. Other than owls, only few bird species do this.

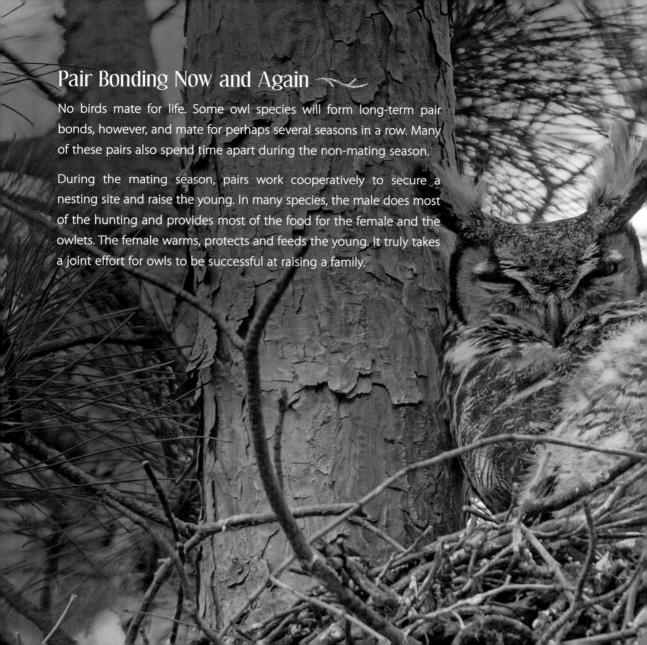

Pair Bonding Now and Again

No birds mate for life. Some owl species will form long-term pair bonds, however, and mate for perhaps several seasons in a row. Many of these pairs also spend time apart during the non-mating season.

During the mating season, pairs work cooperatively to secure a nesting site and raise the young. In many species, the male does most of the hunting and provides most of the food for the female and the owlets. The female warms, protects and feeds the young. It truly takes a joint effort for owls to be successful at raising a family.

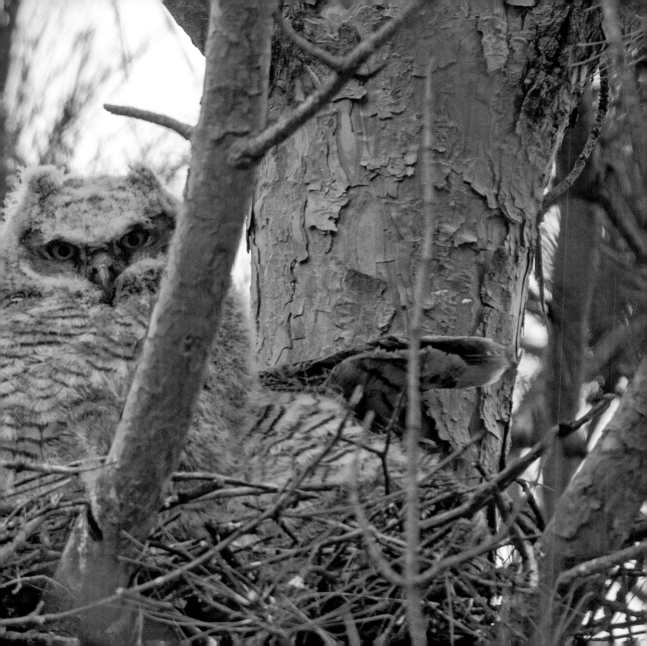

The Time Comes for Nesting

Owls are amazing, but they're not known for handiwork when it comes to nest building. In fact, most owls don't even build nests! Many species, such as the Great Horned Owl, just take over the nest of another bird. Other owls, such as screech-owls, usually nest in a natural cavity of a tree or in an old woodpecker hole. Small cavities are abundant and work well for small owls. Screech-owls keep their cavities bare and don't bring in nesting material.

Barn Owls are cavity nesters that often take advantage of man-made nest boxes in abandoned buildings. Cavity-nesting Barred Owls often nest inside broken tree stumps.

At least one owl species excavates a cavity nest. Burrowing Owls use their feet to dig an underground tunnel upwards of 6 feet long that ends in a small nest chamber. Sometimes they'll use a vacant prairie dog burrow as a head start.

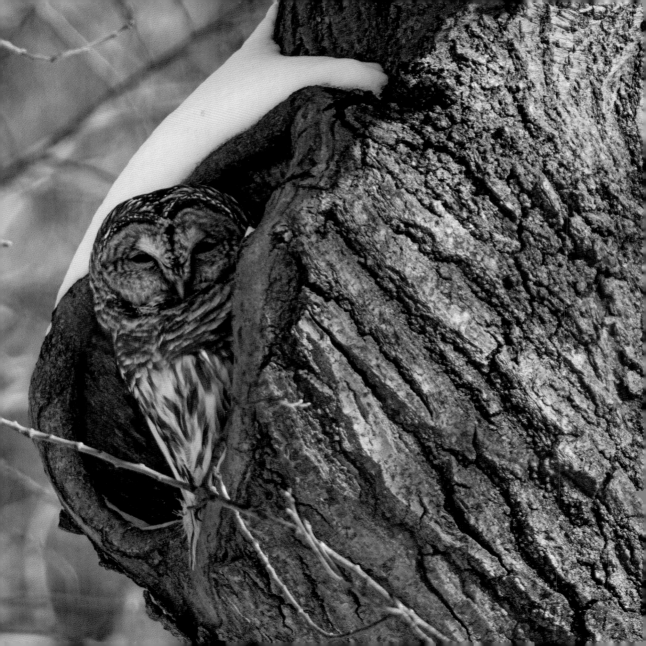

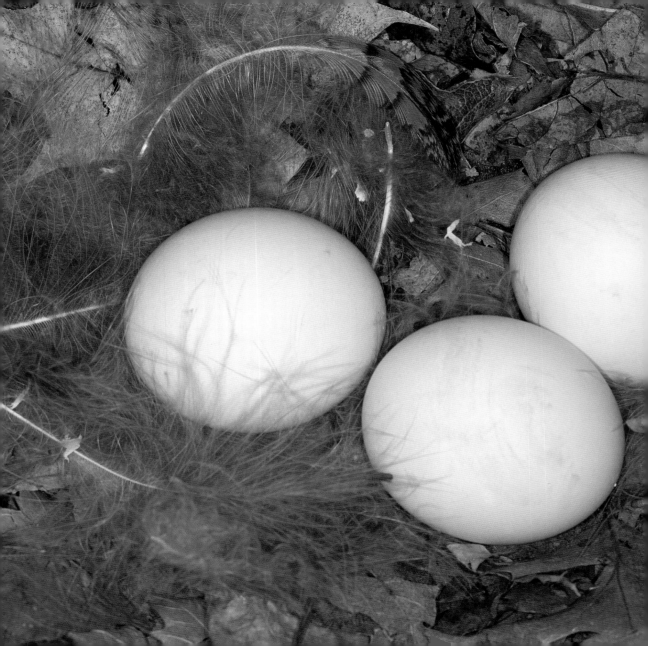

Egg Duty at All Hours

All owls lay mostly round, white eggs. Hidden safely in cavity nests, there's no need for camouflaging speckles or earthy colors.

Many species of birds start incubation only after the entire clutch of eggs is laid. In nearly all owl species, however, incubation begins when the first egg is laid. This is critical for several early-nesting northern owls, especially Great Horned Owls, which nest in January and February, when it is extremely cold in many areas. If an egg freezes, the chick will perish.

In nearly all species of owls, the female incubates the eggs. The male attends to the female during the incubation period, bringing in all the food she needs. He briefly takes her place on the nest a few times each day to give her some much-needed breaks. Oddly enough, when the male sits on the eggs, they only retain the heat imparted by the female!

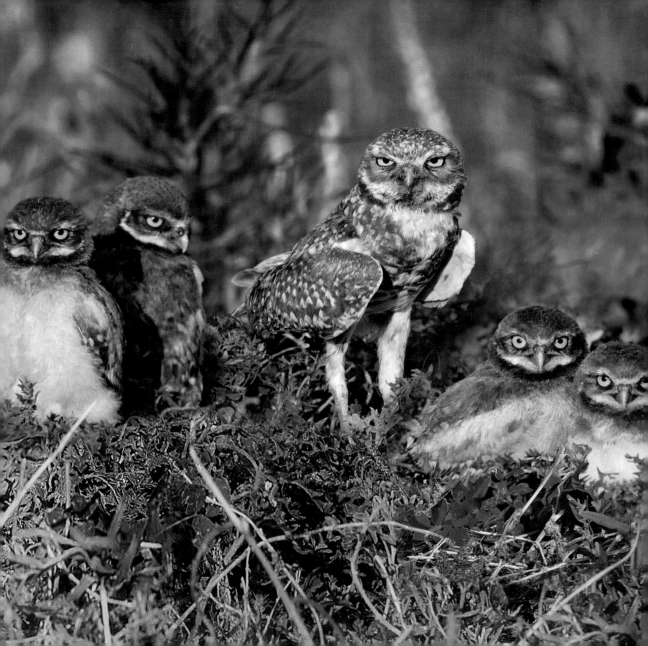

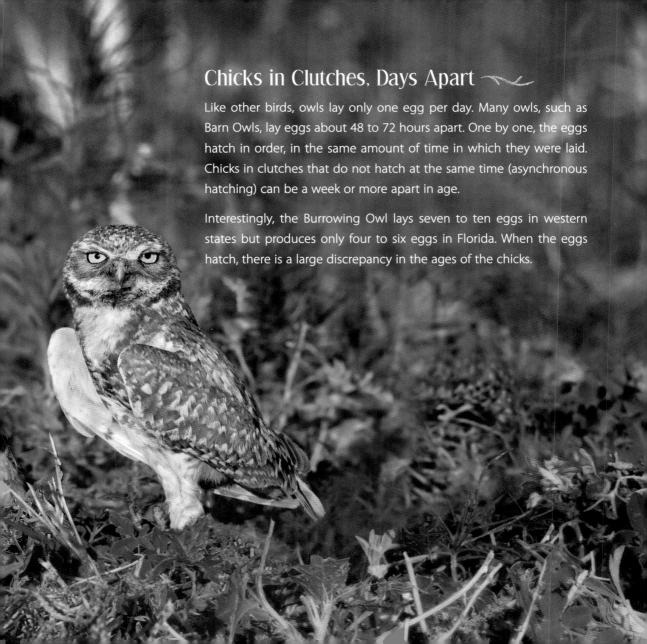

Chicks in Clutches, Days Apart

Like other birds, owls lay only one egg per day. Many owls, such as Barn Owls, lay eggs about 48 to 72 hours apart. One by one, the eggs hatch in order, in the same amount of time in which they were laid. Chicks in clutches that do not hatch at the same time (asynchronous hatching) can be a week or more apart in age.

Interestingly, the Burrowing Owl lays seven to ten eggs in western states but produces only four to six eggs in Florida. When the eggs hatch, there is a large discrepancy in the ages of the chicks.

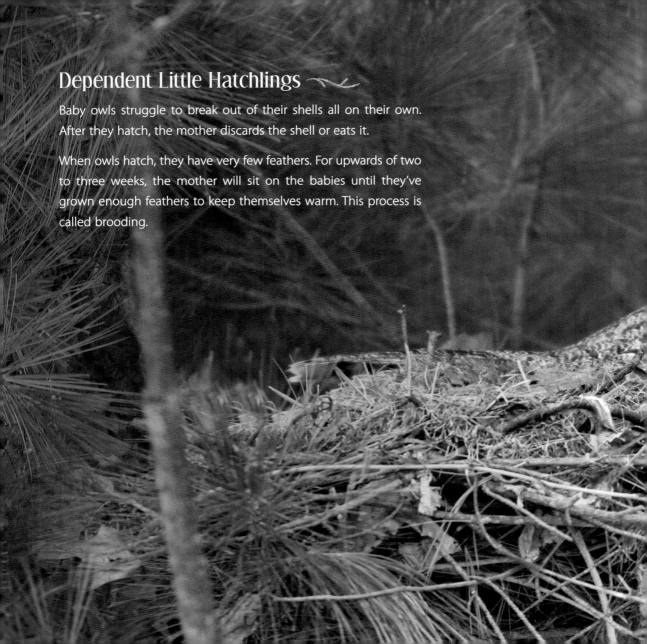

Dependent Little Hatchlings

Baby owls struggle to break out of their shells all on their own. After they hatch, the mother discards the shell or eats it.

When owls hatch, they have very few feathers. For upwards of two to three weeks, the mother will sit on the babies until they've grown enough feathers to keep themselves warm. This process is called brooding.

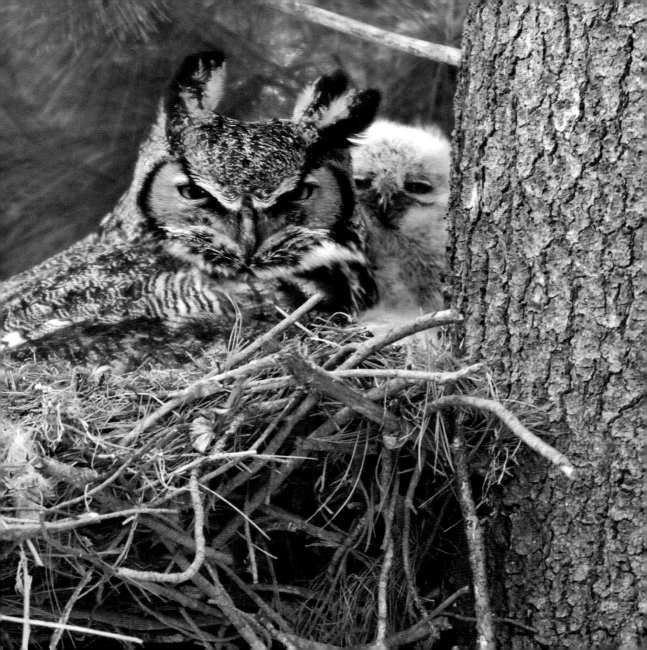

Parents Just Love Their Owlets! ～～

You won't find more dedicated parents than owls. From incubation to fledging and well into an owl's first year, owl parents are devoted to their babies. Most owls invest a lot of time sitting on their eggs, sometimes incubating nearly a month or more. Once the eggs hatch, the mother takes the food that the male brings to the nest, tears it into bite-sized pieces and feeds it to the young. There isn't much fighting over food, and stealing food from one another is rare. In some species, sometimes the oldest chick will even attempt to feed the youngest!

As the chicks grow, the mother begins to offer them whole prey. Sometimes she leaves it in the nest for the owlets to help themselves. Eventually she leaves the nest to help the male hunt and bring in food. During that time, the owlets move around freely. In many owl species, the young leave the nest, or fledge, after 50 to 55 days.

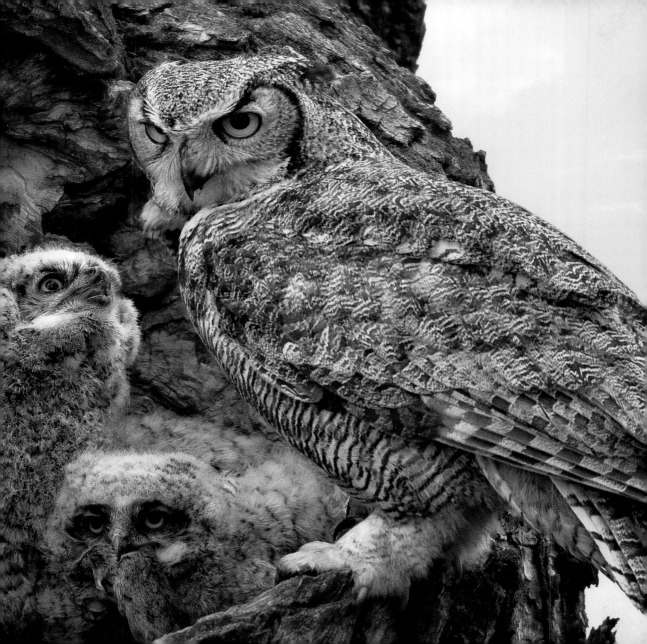

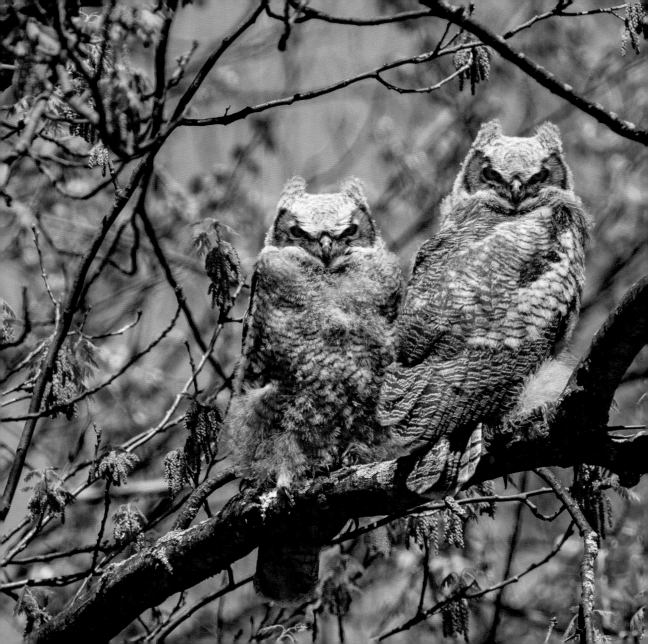

Toughing It Out in Practice

By the end of summer, the adults stop feeding the young. Sitting on branches, the young call loudly for food. The parents are often nearby, but they won't help. After a little tough love, the owlets stop complaining and start to hunt.

Much of a young owl's hunting skills are innate and only need honing or refining. Still, it takes many weeks of practice, with much trial and error, to become a predator that is proficient at capturing and dispatching its own food.

The first attempts at hunting are often clumsy and awkward, but with each challenge the young learn valuable hunting skills. Slowly they become efficient hunters. Starting with smaller prey, like mice and voles, they work their way up to larger mammals, such as rabbits. No matter what, owls need to be competent hunters before their first winter.

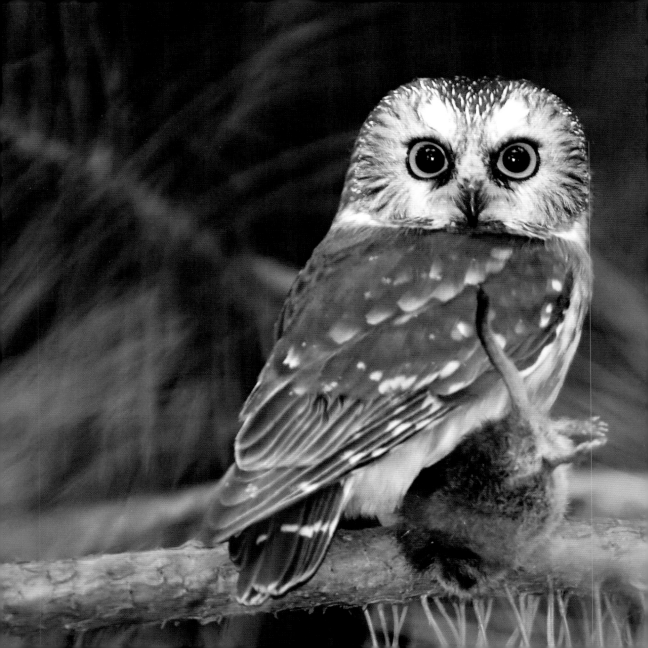

On the Move for Food ～✑

Many owl species don't migrate. They just move around their territory to find food without any well-defined seasonal movement. Other species migrate on a seasonal schedule, leaving at the end of the breeding season and returning in spring. Northern Saw-whet Owls, for example, migrate out of Canada and northern states each year to spend the winter farther south.

Other owls, such as Snowy and Great Gray Owls, have irruptive behavior. Irruption is a highly variable migration. It happens when the food source crashes, and the owls are forced to move out of their range to find food. It also can occur after the rodent population has boomed, and the local owl population has responded by reproducing many owlets. The resulting overpopulation of owls triggers them to move, or irrupt, out of their range. These movements aren't just north and south. During irruption years, owls may disperse in all directions, even east and west.

Back on the Hunt Again

By the end of summer, the amount of daylight has gotten shorter and shorter. The songbirds are no longer singing, and the leaves have changed from deep, forest green to the stunning shades of autumn. Then, one day, the clouds thicken and spit out snowflakes that blanket the landscape with clean snow. Winter has returned, and the owls are back on the hunt, reigning supreme across the land, once again.

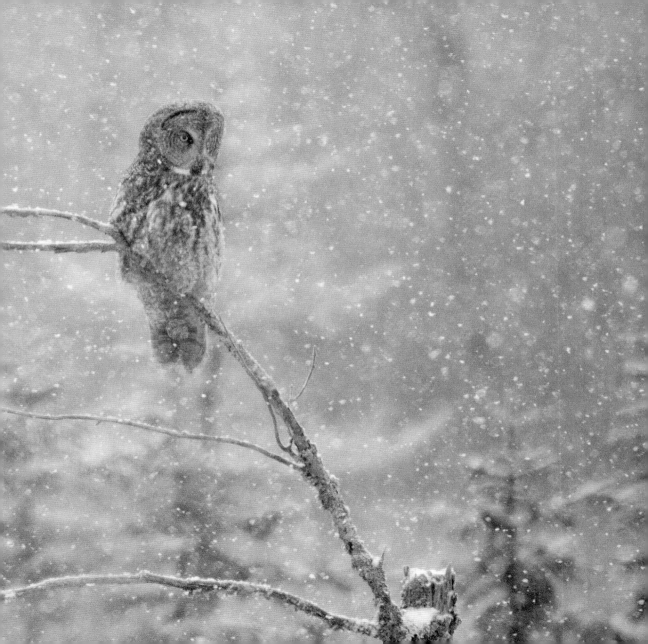

Observation Notes

Date:

_____ _____

_____ _____

_____ _____

_____ _____

_____ _____

_____ _____

_____ _____

_____ _____

_____ _____

_____ _____

_____ _____

_____ _____

_____ _____

_____ _____

Date:

About the Author

Naturalist, wildlife photographer and writer Stan Tekiela is the author of the popular Our Love of Wildlife book series that includes *Our Love of Hummingbirds* and *Our Love of Loons*. He has authored more than 175 field guides, nature books, children's books, wildlife audio CDs, puzzles and playing cards, presenting many species of birds, mammals, reptiles, amphibians, trees, wildflowers and cacti in the United States.

With a Bachelor of Science degree in Natural History from the University of Minnesota and as an active professional naturalist for more than 30 years, Stan studies and photographs wildlife throughout the United States and Canada. He has received various national and regional awards for his books and photographs. Also a well-known columnist and radio personality, his syndicated column appears in more than 25 newspapers and his wildlife programs are broadcast on a number of Midwest radio stations. Stan can be followed on Facebook and Twitter. He can be contacted via www.naturesmart.com.